Mary Koval's Antique Animal Quilts

by Mary Koval and the
editors of Traditional
Quiltworks *magazine*

CHITRA PUBLICATIONS

Your Best Value in Quilting
www.QuiltTownUSA.com

Dedication: I'd like to dedicate this book to my family: my husband Joe, my children Paul, Vicki, and Mary, and my grandaughter Courtney.

Introduction

This book has been written to share a part of my husband Joseph's and my special quilt collection with you. It needs little introduction, as it is complete and clearly told in words and full-color pictures.

Joe and I have been in the antique quilt business for over 30 years. When a quilt dealer decides to collect, it is for a certain reason. In our work, my husband and I have bought, sold, and collected hundreds of quilts for many years and for many reasons: investment, degree of difficulty, age, and reality.

The quilts featured in this book were collected for fun and enjoyment. Other antique quilts in our collections are serious and important, but we wanted and needed to laugh and not always be so serious. So, we purchased the Country Geese quilt first, and then the Charmed Elephants quilt and said, "This is the beginning of something fun." We now have 36 animal quilts... all collected just for fun. Over the years, they have brought pleasure and laughter into our lives. Many of the quilts were made by children or for children. Nothing remains so vivid in the mind of adults as childhood memories of cats, dogs, birds, and other animals.

I wish to express my admiration and affection for the makers of the quilts in this publication. Some of the charming designs were inspired by coloring books while others are completely original. I find myself thoroughly impressed with the creativity and imagination of these quilters.

I present this book to you, the reader, with warm affection. My hope is that it will inspire, inform, and cheer you on to create wonderful, satisfying quilts as it pleasurably brings out the child in you.

Mary Koval

Contents

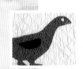
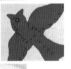
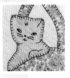
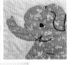

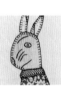
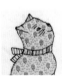

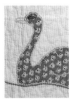

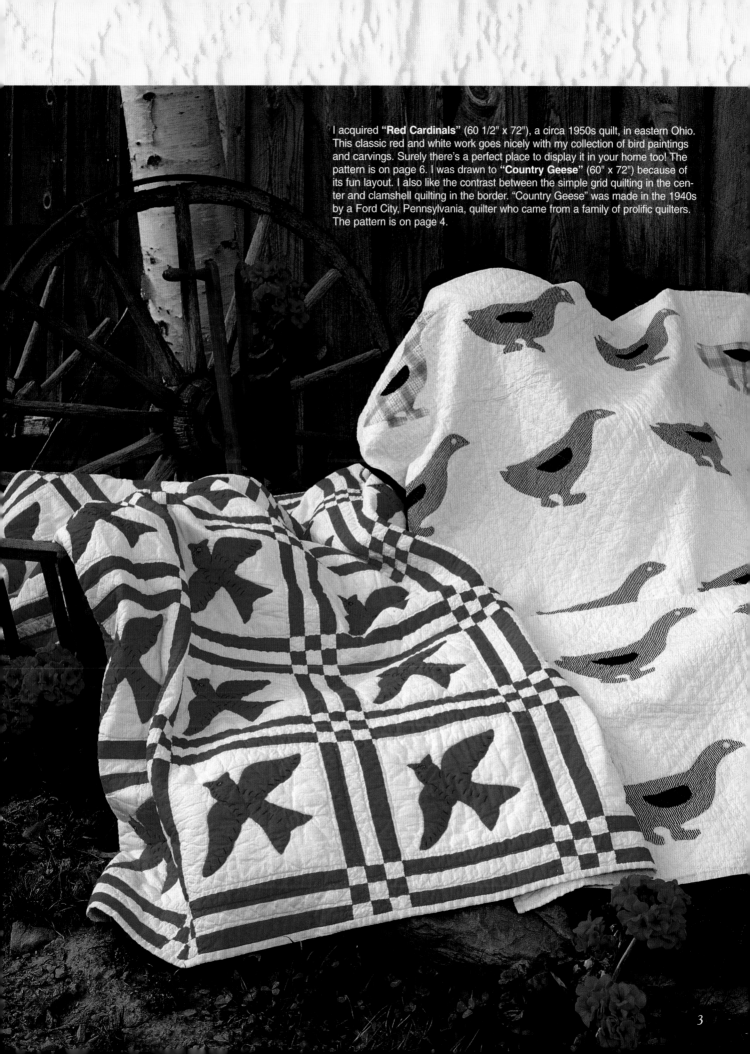

I acquired **"Red Cardinals"** (60 1/2" x 72"), a circa 1950s quilt, in eastern Ohio. This classic red and white work goes nicely with my collection of bird paintings and carvings. Surely there's a perfect place to display it in your home too! The pattern is on page 6. I was drawn to **"Country Geese"** (60" x 72") because of its fun layout. I also like the contrast between the simple grid quilting in the center and clamshell quilting in the border. "Country Geese" was made in the 1940s by a Ford City, Pennsylvania, quilter who came from a family of prolific quilters. The pattern is on page 4.

Country Geese

Shown on page 3

This flock features a few birds of a different feather.

QUILT SIZE: *60" x 72"*

BLOCK SIZE: *12" square*

MATERIALS

- *1 yard black and white stripe*
- *1/4 yard turquoise plaid*
- *2 yards black*
- *2 3/4 yards white*
- *1/8 yard yellow*
- *3 3/4 yards backing fabric*
- *64" x 76" piece of batting*
- *Yellow embroidery floss*

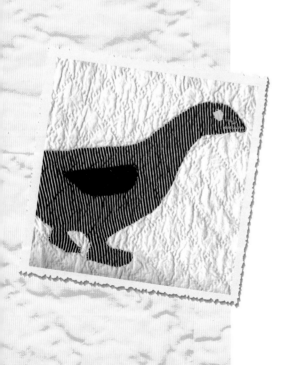

CUTTING

Appliqué patterns are full size and do not include a turn-under allowance. Make a template of each pattern piece. Trace around the templates on the right side of the fabric and add a 1/8" to 3/16" turn-under allowance when cutting the fabric pieces out. All other dimensions include a 1/4" seam allowance. Cut the lengthwise black border and binding strips before cutting smaller pieces from that fabric.

- Cut 16: geese, black and white stripe
- Cut 4: geese, turquoise plaid
- Cut 20: eyes, yellow
- Cut 20: 13" squares, white
- Cut 4: 6" x 63" lengthwise strips, black
- Cut 5: 2 1/2" x 63" lengthwise strips, black, for the binding
- Cut 20: wings, black

DIRECTIONS

- Center and pin a goose on each 13" white square. Needleturn appliqué them in place.
- Appliqué a black wing and yellow eye on each goose.
- Use yellow floss and a blanket stitch to embroider the beaks, as shown.

- Make 16 blocks. Trim them to 12 1/2" square, keeping the geese centered.
- Lay out the blocks in 5 rows of 4 with the turquoise geese in the corners. Stitch them into rows and join the rows.
- Measure the length of the quilt. Trim 2 of the 6" x 63" black strips to that measurement and stitch them to the sides of the quilt.
- Measure the width of the quilt, including the borders. Trim the remaining 6" x 63" black strips to that measurement and stitch them to the top and bottom of the quilt.
- Finish the quilt as described in the *General Directions*, using the 2 1/2" x 63" black strips for the binding.

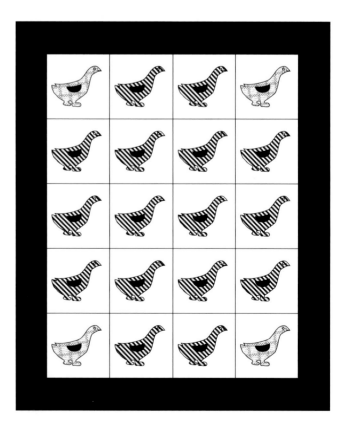

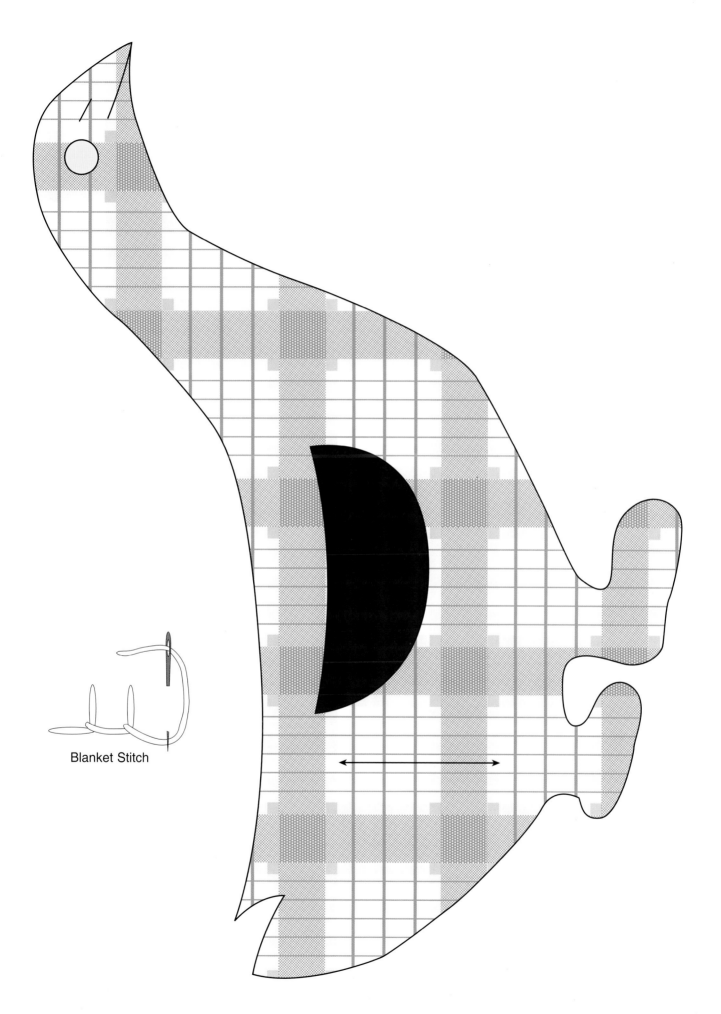

Blanket Stitch

Red Cardinals

Shown on page 3

Appliqué a favorite bird in classic red and white.

QUILT SIZE: 60 1/2" x 72"

BLOCK SIZE: 8 1/2" square

MATERIALS

- *3 yards red*
- *4 yards white*
- *4 yards backing fabric*
- *65" x 76" piece of batting*
- *Black embroidery floss*
- *White embroidery floss*
- *Red embroidery floss (optional)*

CUTTING

Appliqué patterns are full size and do not include a turn-under allowance. Make a template of the pattern piece. Trace around the template on the right side of the fabric and add a 1/8" to 3/16" turn-under allowance when cutting the fabric pieces out. All other dimensions include a 1/4" seam allowance.

- Cut 40: 1 1/2" x 44" strips, red
- Cut 30: cardinals, red
- Cut 30: 9 1/2" squares, white
- Cut 26: 1 1/2" x 44" strips, white
- Cut 7: 2 1/2" x 44" strips, white, for the binding

DIRECTIONS

- Mark the embroidery lines on the right side of a red cardinal.
- Fold a 9 1/2" white square in half diagonally and lightly press the fold. Center the cardinal on the right side of the square, aligning the tips of the wings with the crease.
- Needleturn appliqué the cardinal to the white square. NOTE: *The original quilt-maker used matching red embroidery floss and a blanket stitch to appliqué the cardinals.*
- Embroider the iris of the eye with black embroidery floss and a satin stitch. Embroider a circle around the pupil with white floss and an outline stitch. Embroider the remaining details on the cardinal with black floss and an outline stitch.
- Make 30 blocks. Trim them to 9" square, keeping the cardinals centered.
- Stitch a 1 1/2" x 44" white strip between two 1 1/2" x 44" red strips, along their length. Make 18.
- Cut seventy-one 9" sections and forty-two 1 1/2" sections from the pieced strips.

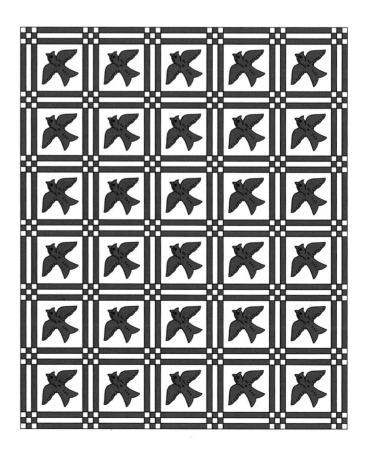

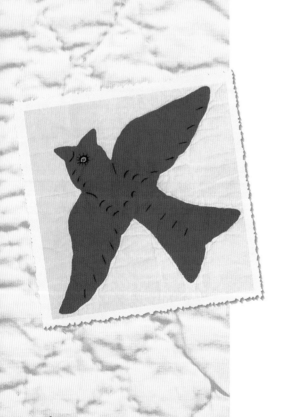

- In the same manner, stitch a 1 1/2" x 44" red strip between two 1 1/2" x 44" white strips. Make 4.
- Cut eighty-four 1 1/2" sections from the pieced strips.
- Lay out a 1 1/2" section with red ends between 2 sections with white ends, as shown. Stitch them together to complete a Nine Patch block. Make 42.

- Lay out 6 Nine Patch blocks alternately with five 9" sections. Stitch them together to complete a sashing. Make 7. Set them aside.

- Lay out 5 cardinal blocks with 9" sections between them and at the beginning and end. Stitch them together to complete a row. Make 6.

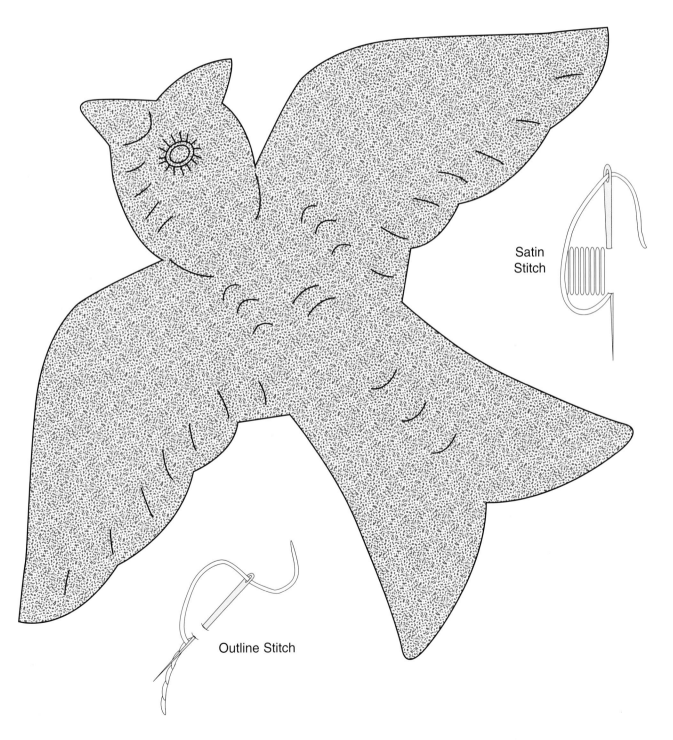

- Lay out the rows alternately with the sashings and stitch them together.
- Finish the quilt as described in the *General Directions*, using the 2 1/2" x 44" white strips for the binding.

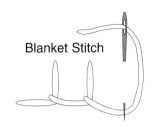

Blanket Stitch

Satin Stitch

Outline Stitch

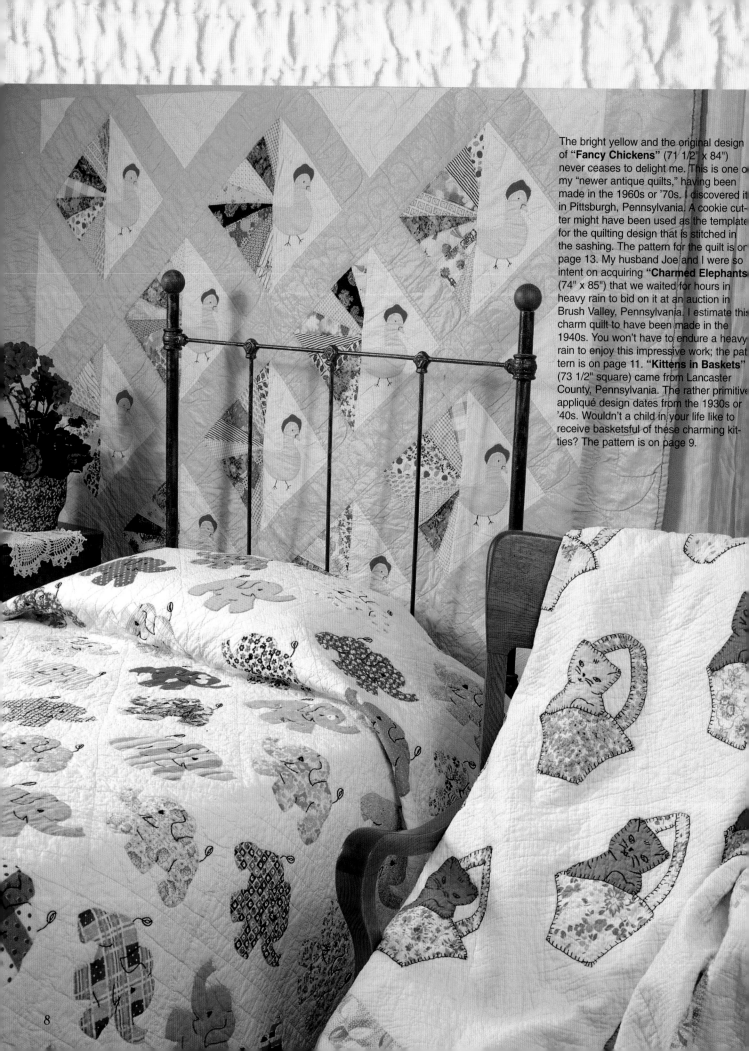

The bright yellow and the original design of **"Fancy Chickens"** (71 1/2" x 84") never ceases to delight me. This is one of my "newer antique quilts," having been made in the 1960s or '70s. I discovered it in Pittsburgh, Pennsylvania. A cookie cutter might have been used as the template for the quilting design that is stitched in the sashing. The pattern for the quilt is on page 13. My husband Joe and I were so intent on acquiring **"Charmed Elephants"** (74" x 85") that we waited for hours in heavy rain to bid on it at an auction in Brush Valley, Pennsylvania. I estimate this charm quilt to have been made in the 1940s. You won't have to endure a heavy rain to enjoy this impressive work; the pattern is on page 11. **"Kittens in Baskets"** (73 1/2" square) came from Lancaster County, Pennsylvania. The rather primitive appliqué design dates from the 1930s or '40s. Wouldn't a child in your life like to receive basketsful of these charming kitties? The pattern is on page 9.

Kittens in Baskets

Shown on page 8

Kittens and quilts just seem to go together.

QUILT SIZE: *73 1/2" square*

BLOCK SIZE: *11" square*

MATERIALS
- *Assorted prints, each at least 9" square, for the baskets*
- *Assorted solids, each at least 5" square, for the kittens*
- *1 3/4 yards blue print*
- *5 yards white*
- *4 1/2 yards backing fabric*
- *78" square of batting*
- *Black embroidery floss*

CUTTING
Appliqué patterns (page 10) are full size and do not include a turn-under allowance. Make a template of each pattern piece. Trace around the templates on the right side of the fabric and add a 1/8" to 3/16" turn-under allowance when cutting the fabric pieces out. All other dimensions include a 1/4" seam allowance. Cut the lengthwise white border and binding strips before cutting smaller pieces from that fabric.

For each of 13 blocks:
- Cut 1 each: basket, handle section A, and handle section B, one print
- Cut 1: kitten, solid

Also:
- Cut 4: 11" x 77" lengthwise strips, white
- Cut 4: 2 1/2" x 77" lengthwise strips, white, for the binding
- Cut 13: 12" squares, white
- Cut 2: 8 5/8" squares, white, then cut them in half diagonally to yield 4 corner triangles
- Cut 2: 16 7/8" squares, white, then cut them in quarters diagonally to yield 8 setting triangles
- Cut 4: 3 1/2" x 55" lengthwise strips, blue print

DIRECTIONS
- Lightly mark the placement of a kitten and a basket, centered and on point, on the right side of each 12" white square.
- Arrange a handle section A, handle section B, basket, and kitten on a marked square. Needleturn appliqué the pieces to the square in the same order.
- Use black floss and a blanket stitch to embroider around each piece.
- Use black floss and an outline stitch to embroider the kitten's face and paws.
- Make 13 blocks. Trim them to 11 1/2" square, keeping the design centered.
- Referring to the assembly diagram, lay out the blocks on point with white corner triangles in the corners and white setting triangles along the edges.

(continued on page 10)

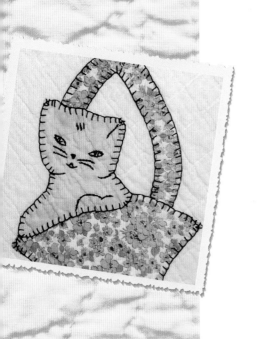

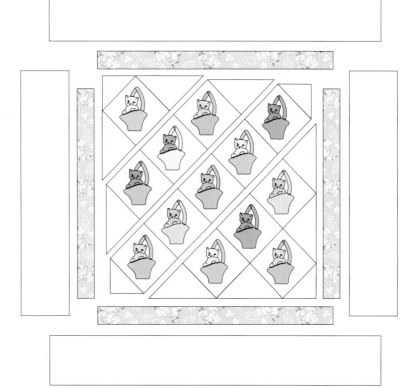

(continued from page 9)

- Stitch the blocks and triangles into diagonal rows and join the rows.
- Measure the length of the quilt. Trim 2 of the 3 1/2" x 55" blue print strips to that measurement. Stitch them to the sides of the quilt.
- Measure the width of the quilt, including the borders. Trim the remaining 3 1/2" x 55" blue print strips to that measurement. Stitch them to the top and bottom of the quilt.
- In the same manner, trim 2 of the 11" x 77" white strips to fit the quilt's length and stitch them to the sides of the quilt.
- Trim the remaining 11" x 77" white strips to fit the quilt's width and stitch them to the top and bottom of the quilt.
- Finish the quilt as described in the *General Directions*, using the 2 1/2" x 77" white strips for the binding.

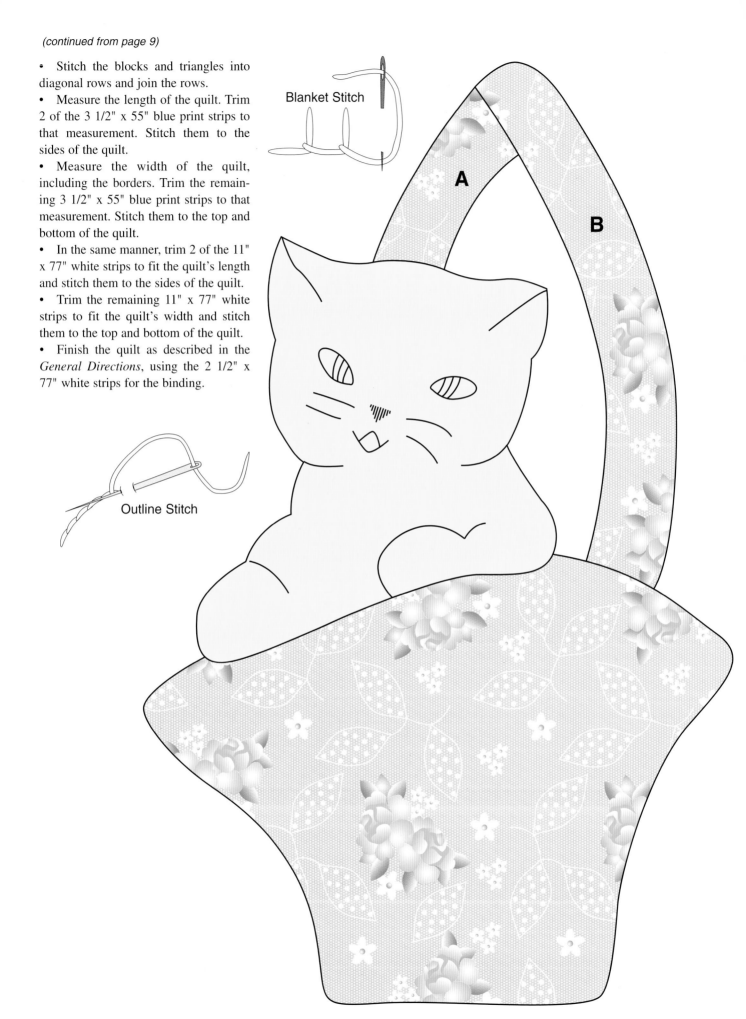

Blanket Stitch

Outline Stitch

A

B

Charmed Elephants

Shown on page 8

Here's the perfect project to showcase your feedsack or reproduction prints.

QUILT SIZE: *74" x 85"*

BLOCK SIZE: *8" square*

MATERIALS

- *Assorted prints, each at least 10" square and totaling at least 3 yards NOTE: To make a charm quilt like the original, you will need 98 different prints.*

- *7 yards white*

- *3/4 yard orange*

- *5 1/8 yards backing fabric*

- *78" x 89" piece of batting*

- *Black embroidery floss*

CUTTING

Appliqué patterns (page 12) are full size and do not include a turn-under allowance. Make a template of each pattern piece. Trace around the templates on the right side of the fabric and add a 1/8" to 3/16" turn-under allowance when cutting the fabric pieces out. All other dimensions include a 1/4" seam allowance. Cut the lengthwise white border strips before cutting smaller pieces from that fabric.

From the assorted prints:
- Cut 42: large elephants facing left
- Cut 30: large elephants facing right
- Cut 11: medium elephants facing left
- Cut 11: medium elephants facing right
- Cut 2: small elephants facing left
- Cut 2: small elephants facing right

Also:
- Cut 4: 3 1/2" x 82" lengthwise strips, white
- Cut 72: 9" squares, white
- Cut 6: 12 5/8" squares, white, then cut them in quarters diagonally to yield 24 setting triangles. You will use 22.
- Cut 2: 6 5/8" squares, white, then cut them in half diagonally to yield 4 corner triangles
- Cut 9: 2 1/2" x 44" strips, orange, for the binding

DIRECTIONS

- Center and pin a large elephant on point on each white square. Needleturn appliqué them in place.
- Use black floss and a satin stitch to embroider the eyes. Use an outline stitch to embroider the tails and other details.
- Make 72 blocks. Trim them to 8 1/2" square, keeping the elephants centered.
- Place a medium elephant in the center of each setting triangle, as shown. NOTE: *The triangles point in 4 different directions when the quilt is assembled. Place the elephants right side up and facing right in 5 triangles that point down, facing left in 5 triangles that point up, facing right in 6 triangles that point to the right, and facing left in 6 triangles that point to the left.*

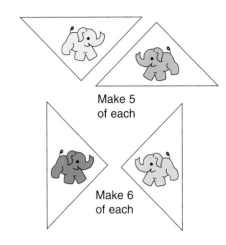

Make 5 of each

Make 6 of each

- Appliqué the elephants and embroider the details, as before.
- Place a small elephant in the center of each corner triangle. NOTE: *The triangles point in 4 different directions, with 2 elephants facing left and 2 elephants facing right, as shown.*

- Appliqué the elephants and embroider the details, as before.
- Lay out the blocks, on point in diagonal rows, as shown in the assembly diagram on page 12. Place setting triangles along the edges and corner triangles in the corners.
- Stitch the blocks and triangles into diagonal rows and join the rows.
- Measure the length of the quilt. Trim 2 of the 3 1/2" x 82" white strips to that measurement. Stitch them to the sides of the quilt.
- Measure the width of the quilt, including the borders. Trim the remaining 3 1/2" x 82" white strips to that measurement. Stitch them to the top and bottom of the quilt.
- Finish the quilt as described in the *General Directions*, using the 2 1/2" x 44" orange strips for the binding.

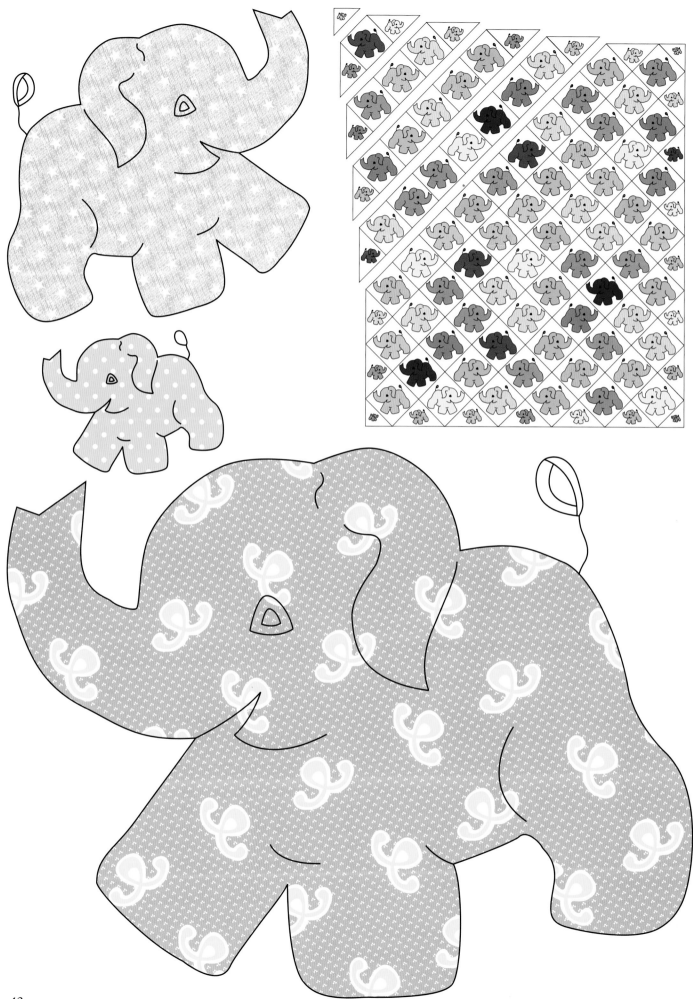

Fancy Chickens

Shown on page 8

It's easier than you think to stitch this unique quilt.

QUILT SIZE: *71 1/2" x 84"*

BLOCK SIZE: *10" square*

MATERIALS

- *Assorted prints, each at least 9" square*
- *4 1/2 yards yellow*
- *1/8 yard red*
- *2 yards white*
- *5 1/4 yards backing fabric*
- *78" x 88" piece of batting*
- *Brown embroidery floss*

CUTTING

Appliqué patterns (page 14) are full size and do not include a turn-under allowance. Make a template of each pattern piece. Trace around the appliqué templates on the right side of the fabric and add a 1/8" to 3/16" turn-under allowance when cutting the fabric pieces out. Pattern pieces A and B (pages 14 and 28) are full size and include a 1/4" seam allowance, as do all dimensions given. Cut the lengthwise yellow sashing strips before cutting smaller pieces from that fabric.

For each of 15 blocks:
- Cut 2 each of the following pieces: A, AR, B, BR, assorted prints

Also:
- Cut 8: 11 1/2" squares, white, then cut them in half diagonally to yield 16 triangles for the blocks. You will use 15.
- Cut 3: 15 3/8" squares, white, then cut them in quarters diagonally to yield 12 setting triangles. You will use 11.
- Cut 1: 8" square, white, then cut it in half diagonally to yield 2 corner triangles.
- Cut 15: coxcombs, red
- Cut 4: 2 1/2" x 85" lengthwise strips, yellow, for the binding
- Cut 4: 7 1/2" x 75" lengthwise strips, yellow, for the borders
- Cut 1: 4" x 85" lengthwise strip, yellow
- Cut 1: 4" x 71 1/2" lengthwise strip, yellow
- Cut 1: 4" x 58" lengthwise strip, yellow
- Cut 1: 4" x 44 1/2" lengthwise strip, yellow
- Cut 1: 4" x 31" strip, yellow
- Cut 1: 4" x 17 1/2" strip, yellow
- Cut 21: 4" x 10 1/2" strips, yellow
- Cut 15: chickens, yellow

DIRECTIONS

- Lay out an A, B, BR, and AR, as shown. Sew them together to make a pieced triangle. Repeat to form a second pieced triangle. Join the pieced triangles to complete a tail unit. Make 15. Set them aside.

- Fold a white triangle (cut from an 11 1/2" square) in half and lightly press the fold to mark the center.

- Lightly mark the placement of a chicken on the right side of the triangle, placing the top of the chicken's back on the crease. Align the straight edge of the chicken with the edge of the triangle.
- Needleturn appliqué a red coxcomb and then a yellow chicken on each marked white triangle.
- Use brown floss and a satin stitch to embroider each chicken's eye. Use an outline stitch to embroider the remaining details.
- Make 15 chicken triangles.
- Center and sew a tail unit to a chicken triangle to make a block, as shown. The chicken triangle will be slightly larger than the tail unit. Make 15. NOTE: *Take care not to stretch the bias edges.*

(continued on page 14)

(continued from page 13)

- Press the seam allowances toward the tail units.
- Trim the chicken triangles to square the blocks to 10 1/2".
- Lay out the blocks on point, as shown in the assembly diagram, with 4" x 10 1/2" yellow strips between the blocks, and white setting triangles along the edges. Stitch the blocks, strips, and setting triangles into diagonal rows.
- Lay out the rows with the 4"-wide yellow strips between them, as shown. NOTE: *The strips will extend beyond the edges of the quilt, as shown in the assembly diagram.*
- Stitch the rows and strips together.

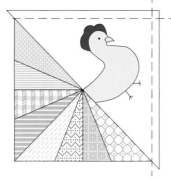

- Stitch the corner triangles to the upper corners of the quilt.
- Trim the ends of the yellow strips even with the triangles.
- Measure the length of the quilt. Trim 2 of the 7 1/2" x 75" yellow strips to that measurement. Stitch them to the sides of the quilt.
- Measure the width of the quilt, including the borders. Trim the remaining 7 1/2" x 75" yellow strips to that measurement. Stitch them to the top and bottom of the quilt.
- Finish the quilt as described in the *General Directions*, using the 2 1/2" x 85" yellow strips for the binding.

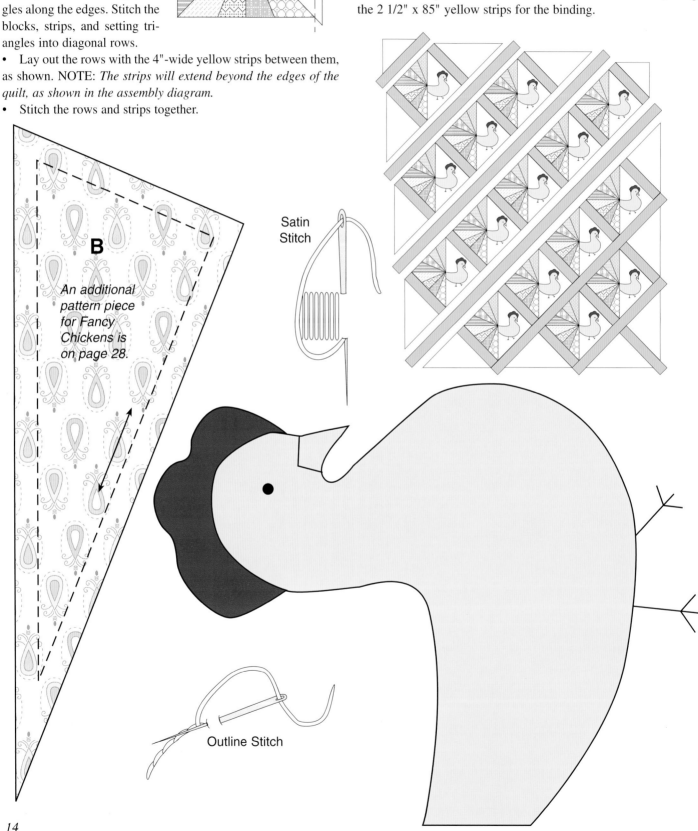

B

An additional pattern piece for Fancy Chickens is on page 28.

Satin Stitch

Outline Stitch

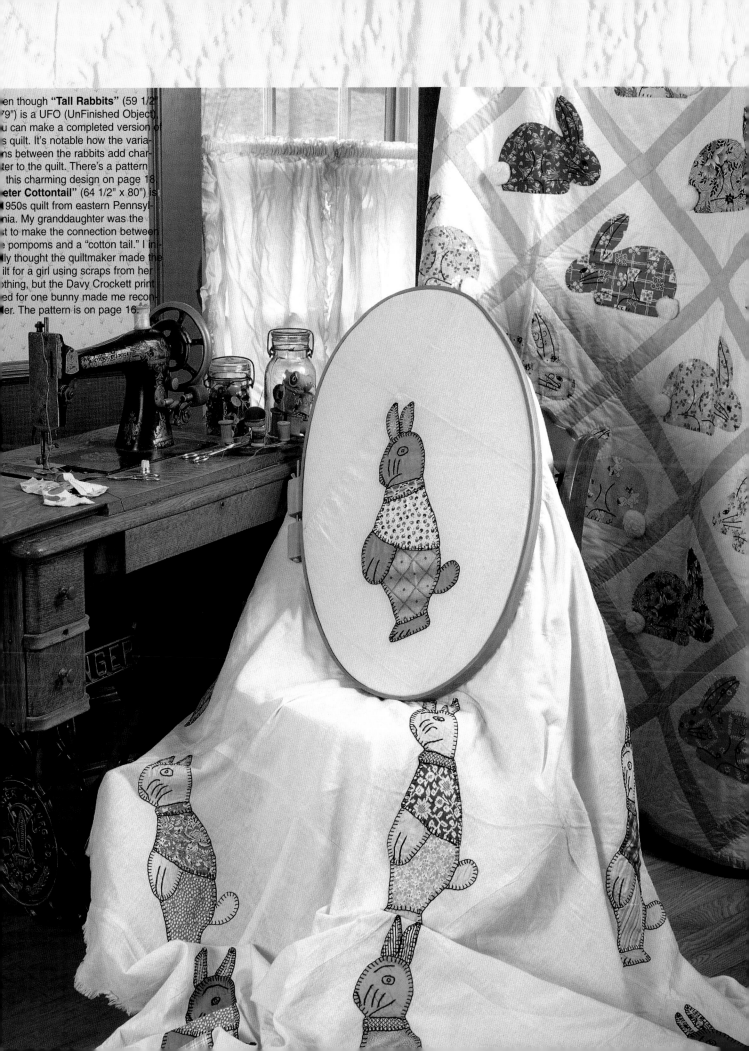

en though **"Tall Rabbits"** (59 1/2"
79") is a UFO (UnFinished Object),
u can make a completed version of
s quilt. It's notable how the varia-
ns between the rabbits add char-
ter to the quilt. There's a pattern
 this charming design on page 18

eter Cottontail" (64 1/2" x 80") is
 1950s quilt from eastern Pennsyl-
nia. My granddaughter was the
t to make the connection between
 pompoms and a "cotton tail." I in-
ly thought the quiltmaker made the
ilt for a girl using scraps from her
thing, but the Davy Crockett print
d for one bunny made me recon-
er. The pattern is on page 16.

Peter Cottontail

Shown on page 15

Hop to it, and you'll finish this quilt in no time.

QUILT SIZE: *64 1/2" x 80"*

BLOCK SIZE: *9 1/2" square*

MATERIALS
- Assorted prints, each at least 9" square
- 2 3/4 yards blue
- 4 1/2 yards white
- 5 yards backing fabric
- 69" x 84" piece of batting
- Black embroidery floss
- White 4-ply yarn for the pompoms

CUTTING
Appliqué patterns are full size and do not include a turn-under allowance. Make a template of the pattern piece. Trace around the template on the right side of the fabric and add a 1/8" to 3/16" turn-under allowance when cutting the fabric pieces out. All other dimensions include a 1/4" seam allowance.
- Cut 20: rabbits facing left, assorted prints
- Cut 12: rabbits facing right, assorted prints
- Cut 32: 10 1/2" squares, white
- Cut 2: 9 3/4" squares, white, then cut them in half diagonally to yield 4 corner triangles
- Cut 4: 16 7/8" squares, white, then cut them in quarters diagonally to yield 16 setting triangles. You will use 14.
- Cut 1: 2" x 90" lengthwise strip, blue
- Cut 4: 2 1/2" x 90" lengthwise strips, blue, for the binding
- Cut 2: 2" x 79" lengthwise strips, blue
- Cut 2: 2" x 57" lengthwise strips, blue
- Cut 2: 2" x 35" lengthwise strips, blue
- Cut 2: 2" x 13" lengthwise strips, blue

- Cut 40: 2" x 10" lengthwise strips, blue

DIRECTIONS
- Center and pin a rabbit on point in each white square. Needleturn appliqué them in place.
- Use black floss and a satin stitch to embroider each rabbit's eye. Use an outline stitch to embroider the remaining details.
- Make 32 blocks. Trim them to 10" square, keeping the rabbit centered.
- Referring to the assembly diagram, lay out the blocks on point with 2" x 10" blue strips between the blocks and the remaining 2"-wide strips between the diagonal rows. Place white corner triangles in the corners and white setting triangles along the edges.
- Stitch the blocks, strips, and triangles into diagonal rows and join the rows.
- Finish the quilt as described in the *General Directions*, using the 2 1/2" x 90" blue strips for the binding.
- Make 32 pompoms using the white yarn. Referring to the quilt photo for placement, stitch a pompom to each rabbit.

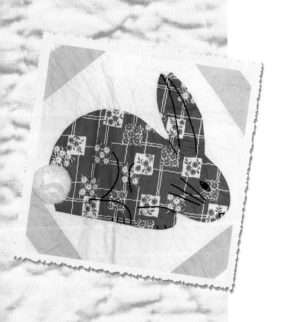

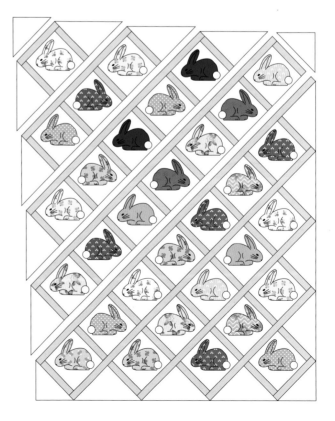

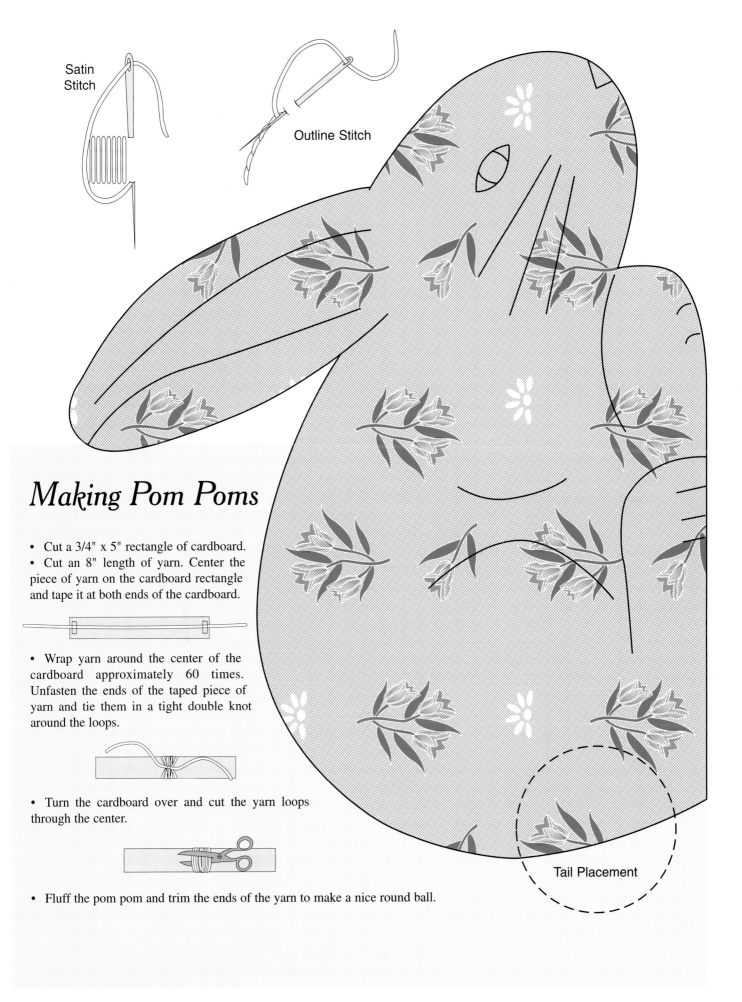

Satin Stitch

Outline Stitch

Making Pom Poms

- Cut a 3/4" x 5" rectangle of cardboard.
- Cut an 8" length of yarn. Center the piece of yarn on the cardboard rectangle and tape it at both ends of the cardboard.

- Wrap yarn around the center of the cardboard approximately 60 times. Unfasten the ends of the taped piece of yarn and tie them in a tight double knot around the loops.

- Turn the cardboard over and cut the yarn loops through the center.

- Fluff the pom pom and trim the ends of the yarn to make a nice round ball.

Tail Placement

Tall Rabbits

Shown on page 15

These unusual rabbits are snappy dressers!

QUILT SIZE: *59 1/2" x 79"*

BLOCK SIZE: *14" square*

MATERIALS

- *Assorted prints, each at least 6" square*

- *Assorted solids, each at least 8" square*

- *6 yards white*

- *3/4 yard fabric for binding*

- *5 yards backing fabric*

- *64" x 83" piece of batting*

- *Black embroidery floss*

CUTTING

Appliqué patterns are full size and do not include a turn-under allowance. Make a template of each pattern piece. Trace around the templates on the right side of the fabric and add a 1/8" to 3/16" turn-under allowance when cutting the fabric pieces out. All other dimensions include a 1/4" seam allowance.

For each of 9 blocks:

- Cut 1 each: head, paw, tail, and foot, solid
- Cut 2: ears, one print
- Cut 1: shirt, second print
- Cut 1: collar, third print
- Cut 1: pants, fourth print

Also:

- Cut 2: 20 3/4" squares, white, then cut them in half diagonally to yield 4 corner triangles
- Cut 2: 21 1/8" squares, white, then cut them in quarters diagonally to yield 8 setting triangles. You will use 6.
- Cut 9: 15" squares, white
- Cut 8: 14 1/2" squares, white
- Cut 8: 2 1/2" x 44" strips, binding fabric

DIRECTIONS

- Lightly mark the placement of a rabbit, centered and on point, on the right side of each 15" white square.
- Arrange the pieces for one block on a marked square. Appliqué the pieces on the square in this order: ears, head, tail, foot, pants, paw, shirt, and collar.
- Use black floss and a blanket stitch to embroider around the pieces in the same order. Embroider the remaining details with an outline stitch.
- Make 9 blocks. Trim them to 14 1/2" square, keeping the rabbits centered.
- Lay out the blocks on point in 3 rows of 3. Place 14 1/2" white squares between the blocks, white corner triangles in the corners, and white setting triangles along the edges, as shown in the assembly diagram.
- Stitch the blocks, squares, and triangles into diagonal rows and join the rows.
- Finish the quilt as described in the *General Directions*, using the 2 1/2" x 44" strips for the binding.

Blanket Stitch

Outline Stitch

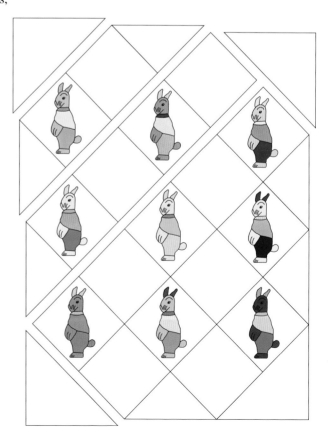

18

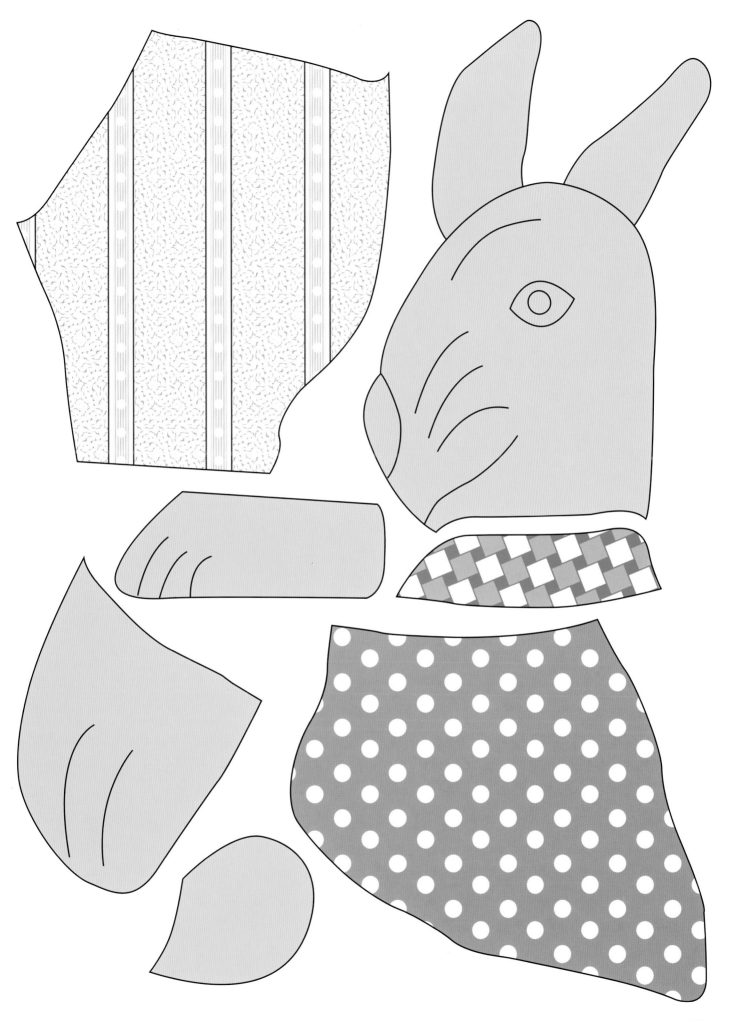

19

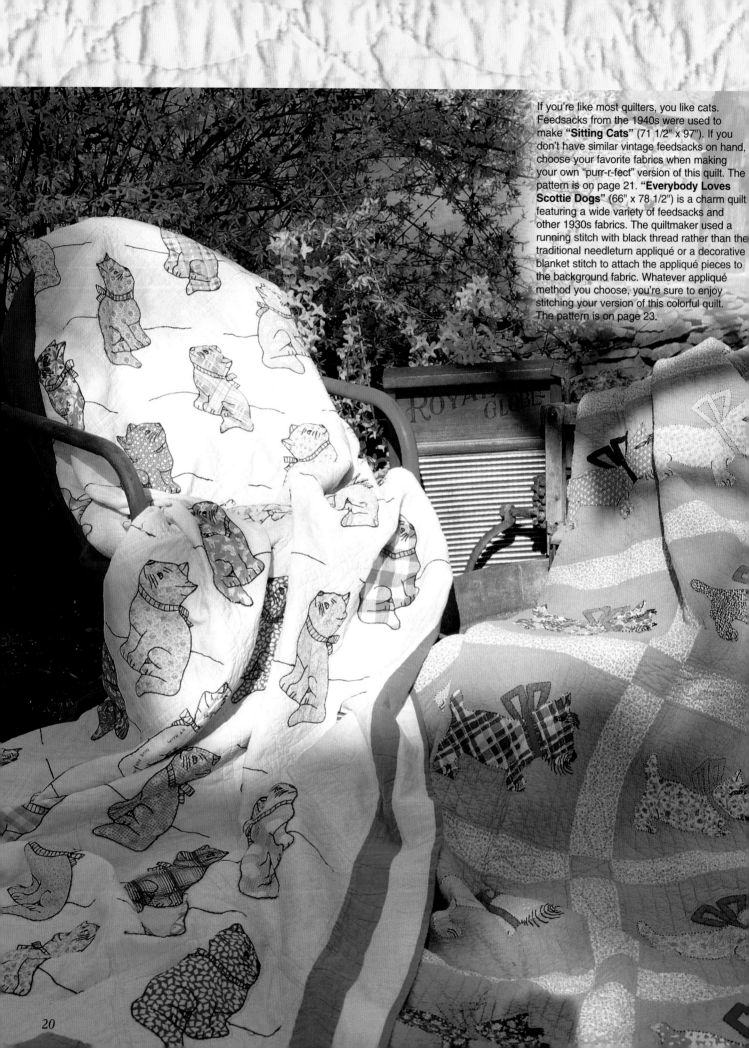

If you're like most quilters, you like cats. Feedsacks from the 1940s were used to make **"Sitting Cats"** (71 1/2" x 97"). If you don't have similar vintage feedsacks on hand, choose your favorite fabrics when making your own "purr-r-fect" version of this quilt. The pattern is on page 21. **"Everybody Loves Scottie Dogs"** (66" x 78 1/2") is a charm quilt featuring a wide variety of feedsacks and other 1930s fabrics. The quiltmaker used a running stitch with black thread rather than the traditional needleturn appliqué or a decorative blanket stitch to attach the appliqué pieces to the background fabric. Whatever appliqué method you choose, you're sure to enjoy stitching your version of this colorful quilt. The pattern is on page 23.

Sitting Cats

These felines give new meaning to "calico" cat!

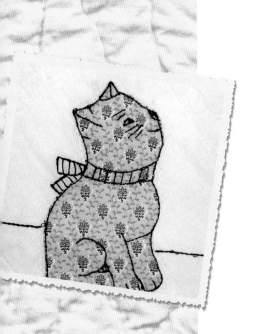

Shown on page 20

QUILT SIZE: *71 1/2" x 97"*

BLOCK SIZE: *9" square*

MATERIALS

- *Assorted prints, each at least 9" square*

- *4 1/2 yards white*

- *2 3/4 yards blue*

- *6 yards backing fabric*

- *76" x 101" piece of batting*

- *Black embroidery floss*

CUTTING

The appliqué pattern (page 22) is full size and does not include a turn-under allowance. Make a template of the pattern piece. Trace around the template on the right side of the fabric and add a 1/8" to 3/16" turn-under allowance when cutting the fabric pieces out. All other dimensions include a 1/4" seam allowance. Cut the lengthwise white border strips before cutting smaller pieces from that fabric.

- Cut 35: cats facing right, assorted prints
- Cut 24: cats facing left, assorted prints
- Cut 4: 2 1/2" x 95" lengthwise strips, white
- Cut 59: 10" squares, white
- Cut 2: 7 1/4" squares, white, then cut them in half diagonally to yield 4 corner triangles
- Cut 5: 14" squares, white, then cut them in quarters diagonally to yield 20 setting triangles
- Cut 8: 2 1/2" x 95" lengthwise strips, blue, for the border and binding

DIRECTIONS

- Lightly mark the placement of a right facing cat and embroidery line, centered and on point on the right side of thirty-five 10" white squares. Mark the placement of a left facing cat and embroidery line on the remaining 10" white squares.
- Needleturn appliqué a cat on each white square.
- Using black floss and an outline stitch, embroider around the edge of the cat. Embroider the collar, bow, and the remaining details.
- Make 59 blocks. Trim them to 9 1/2" square, keeping the cats centered.

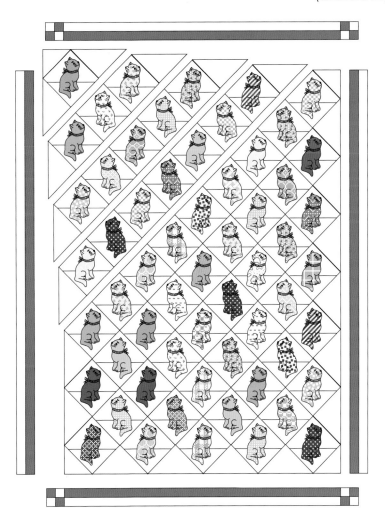

(continued on page 22)

(continued from page 21)

- Lay out the blocks on point with white corner triangles in the corners and white setting triangles along the edges, as shown in the assembly diagram on page 21.
- Stitch the blocks and triangles into diagonal rows and join the rows.
- Stitch a 2 1/2" x 95" white strip to a 2 1/2" x 95" blue strip, along their length, to make a border strip. Make 4.
- Measure the width of the quilt. Trim 2 border strips to that measurement.
- Cut eight 2 1/2" sections from the remnants of these border strips.

- Stitch 2 sections together to form a Four Patch unit. Make 4.

- Referring to the assembly diagram on page 21, stitch a Four Patch unit to each end of the trimmed border strips. Set them aside.
- Measure the length of the quilt. Trim the remaining border strips to that measurement. Stitch them to the long sides of the quilt, placing the blue strip against the quilt.
- Stitch the pieced borders to the top and bottom of the quilt in the same manner.
- Finish the quilt as described in the *General Directions*, using the remaining 2 1/2" x 95" blue strips for the binding.

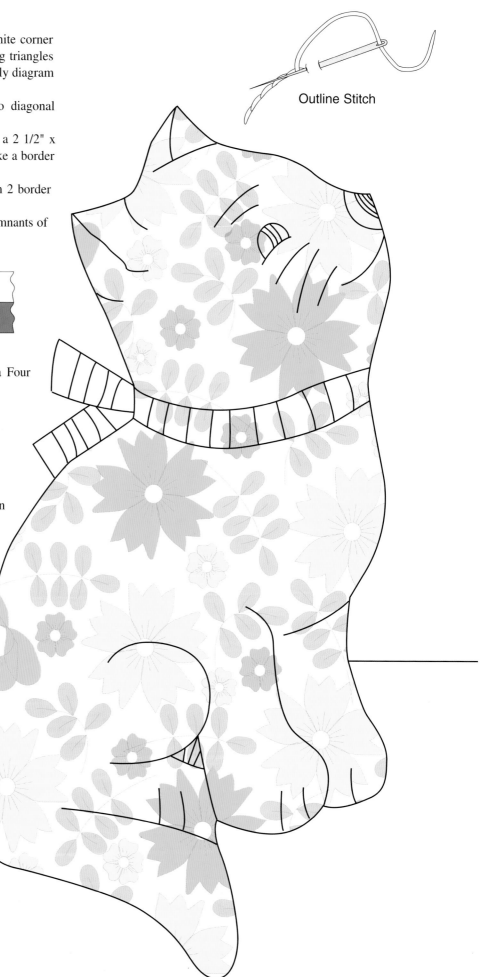

Outline Stitch

Everybody Loves Scottie Dogs

Shown on page 20

A colorful background is surprisingly perfect for these jaunty terriers.

QUILT SIZE: 66" x 78 1/2"

BLOCK SIZE: 10" square

MATERIALS

- 30 assorted prints, each at least 9" square

- 30 assorted solids, each at least 7" square

- 4 yards lavender

- 2 1/4 yards white print

- 3/4 yard white

- 5 yards backing fabric

- 70" x 83" piece of batting

- Black embroidery floss

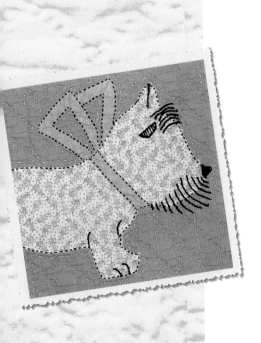

CUTTING

The appliqué pattern (page 24) is full size and does not include a turn-under allowance. Make a template of the pattern piece. Trace around the template on the right side of the fabric and add a 1/8" to 3/16" turn-under allowance when cutting the fabric pieces out. All other dimensions include a 1/4" seam allowance.

For each of 30 blocks:
- Cut 1: Scottie, print
- Cut 1: 1" x 3" strip, solid
- Cut 2: 1" x 8" bias strips, same solid

Also:
- Cut 30: 11" squares, lavender
- Cut 42: 3" squares, lavender
- Cut 71: 3" x 10 1/2" strips, white print
- Cut 8: 2 1/2" x 44" strips, white, for the binding

DIRECTIONS

For each block:
- Lightly mark the placement of a Scottie and the bow, centered, on the right side of each 11" lavender square.

- Turn under the long edges of the 1" x 8" solid bias strips, and pin them in place along the placement lines of the bow, forming a miter where the strips turn corners.

- Needleturn appliqué the bias strips in place.
- Appliqué the Scottie in place, covering the raw edges of the bias strips. Appliqué the 1" x 3" solid strip to the Scottie's neck for the collar.
- Using black floss and a satin stitch, embroider the nose. Embroider the eye, whiskers, and other details with an outline stitch.
- Make 30 blocks. Trim them to 10 1/2" square, keeping the Scotties centered.

(continued on page 24)

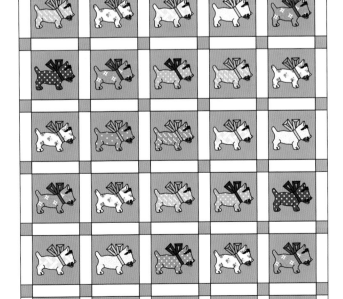

(continued from page 23)

• Lay out six 3" lavender squares alternately with five 3" x 10 1/2" white print strips. Stitch them together to complete a pieced sashing. Make 7.

• Lay out the rows with the pieced sashings between them and at the top and bottom. Stitch them together.

• Finish the quilt as described in the *General Directions*, using the 2 1/2" x 44" white strips for the binding.

• Lay out 5 blocks with 3" x 10 1/2" white print strips between them and at the beginning and end. Stitch them together to complete a row. Make 6.

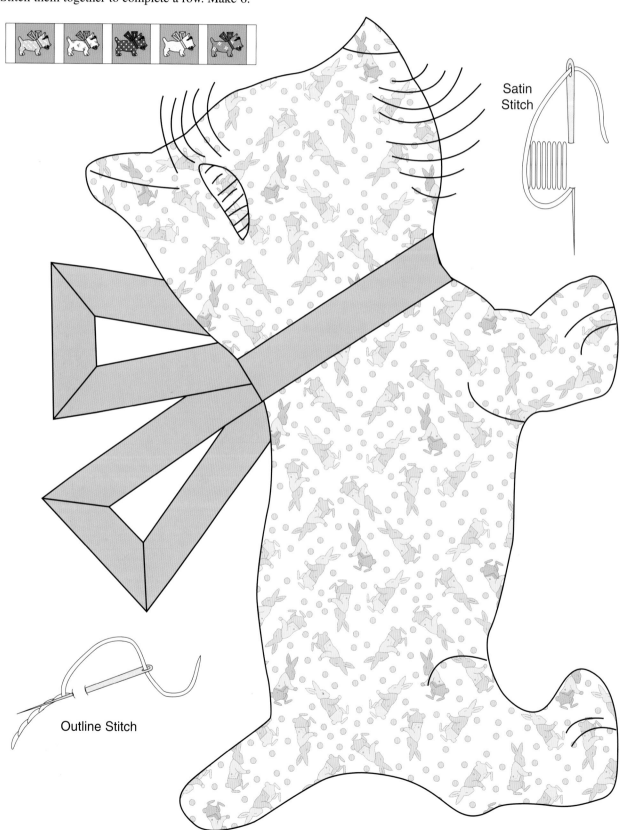

Satin Stitch

Outline Stitch

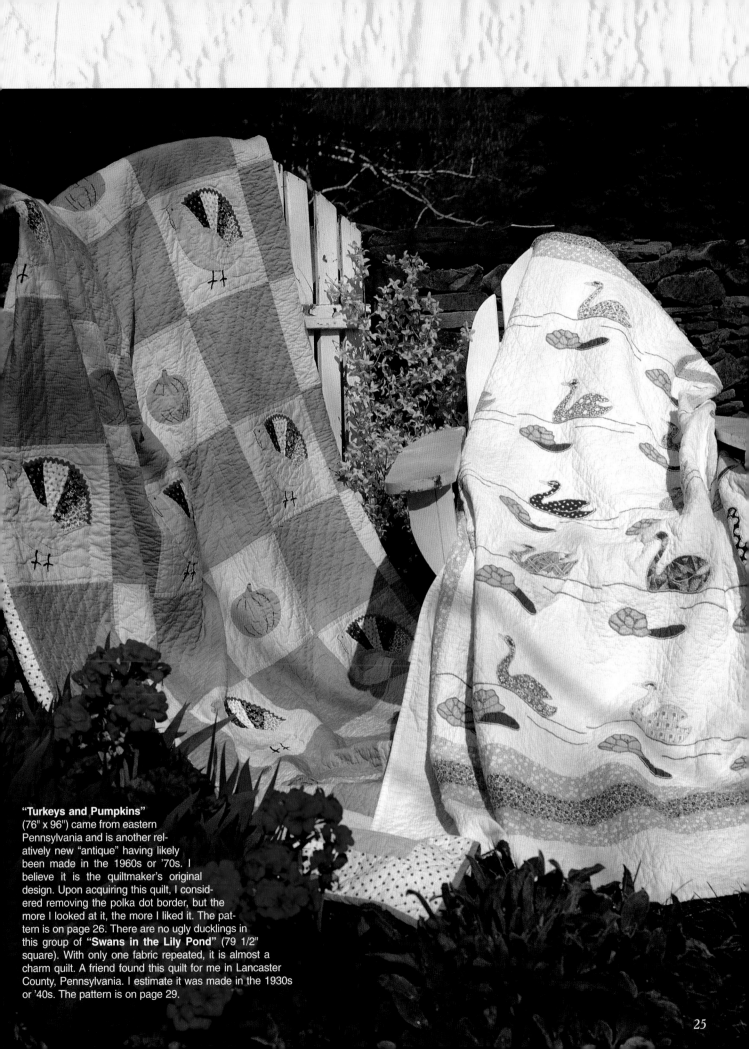

"Turkeys and Pumpkins"
(76" x 96") came from eastern
Pennsylvania and is another rel-
atively new "antique" having likely
been made in the 1960s or '70s. I
believe it is the quiltmaker's original
design. Upon acquiring this quilt, I consid-
ered removing the polka dot border, but the
more I looked at it, the more I liked it. The pat-
tern is on page 26. There are no ugly ducklings in
this group of **"Swans in the Lily Pond"** (79 1/2"
square). With only one fabric repeated, it is almost a
charm quilt. A friend found this quilt for me in Lancaster
County, Pennsylvania. I estimate it was made in the 1930s
or '40s. The pattern is on page 29.

Turkeys and Pumpkins

Shown on page 25

Shouldn't everyone have a Thanksgiving quilt?

QUILT SIZE: *76" x 96"*

BLOCK SIZE: *10" square*

MATERIALS

- *3/4 yard blue*
- *1/2 yard pink*
- *1/2 yard orange*
- *1/8 yard teal*
- *3 1/2 yards purple*
- *1/8 yard black print*
- *1/8 yard white print*
- *1/8 yard black and blue print*
- *1/8 yard blue and white print*
- *3 1/2 yards tan*
- *1 yard purple polka dot*
- *5 1/2 yards backing fabric*
- *80" x 100" piece of batting*
- *4 yards red rickrack*
- *Black embroidery floss*
- *Red embroidery floss*

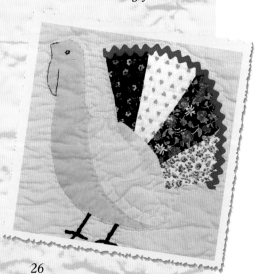

CUTTING

Appliqué patterns (pages 27 and 28) are full size and do not include a turn-under allowance. Make a template of each pattern piece. Trace around the appliqué templates on the right side of the fabric and add a 1/8" to 3/16" turn-under allowance when cutting the fabric pieces out. Patterns A and B (page 28) are full size and include a 1/4" seam allowance as do all dimensions given.

- Cut 20: bodies, blue
- Cut 20: wings, pink
- Cut 20: A, black print
- Cut 20: B, white print
- Cut 20: BR, black and blue print
- Cut 20: AR, blue and white print
- Cut 12: pumpkins, orange
- Cut 12: stems, teal
- Cut 32: 11" squares, tan
- Cut 8: 3 1/2" x 44" strips, purple polka dot
- Cut 20: 8 1/2" lengths, rickrack
- Cut 31: 10 1/2" squares, purple
- Cut 9: 2 1/2" x 44" strips, purple, for the binding

DIRECTIONS

- Lightly mark the placement of a turkey, centered, on the right side of 20 of the 11" tan squares. Mark the placement of a pumpkin and stem, centered, on the right side of the 12 remaining 11" tan squares.

For each turkey block:

- Lay out an A, B, BR, and AR. Stitch them together to make a tail unit.

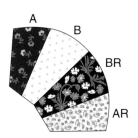

- Needleturn appliqué a tail unit to a tan square. Next appliqué a blue turkey body and then a pink wing to the square.
- Stitch an 8 1/2" length of rickrack to the long curved edge of the tail, tucking the ends under.

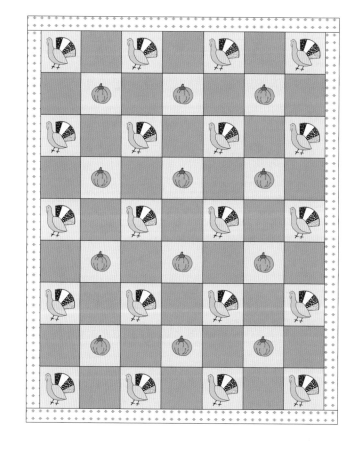

- Use red floss and an outline stitch to embroider around the turkey beak and beard. Use black floss and a satin stitch to embroider the feet, and an outline stitch to embroider the eye.
- Make 20 turkey blocks. Trim them to 10 1/2" square, keeping the turkeys centered.
- Appliqué the pumpkins and then the stems to the remaining tan squares.
- Use black floss and an outline stitch to embroider the details on the pumpkins and stems.
- Trim the blocks to 10 1/2" square,

keeping the pumpkins centered.
- Lay out 4 turkey blocks alternately with three 10 1/2" purple squares. Stitch them together to complete a turkey row. Make 5.
- Lay out 3 pumpkin blocks alternately with four 10 1/2" purple squares. Stitch them together to complete a pumpkin row. Make 4.
- Lay out the turkey rows alternately with the pumpkin rows, beginning and ending with a turkey row. Stitch them together.
- Stitch the 3 1/2" x 44" purple polka dot strips together, end to end, to make a long pieced strip.

- Measure the length of the quilt. Cut 2 lengths from the pieced strip each equal to that measurement. Stitch them to the sides of the quilt.
- Measure the width of the quilt, including the borders. Cut 2 lengths from the pieced strip each equal to that measurement. Stitch them to the top and bottom of the quilt.
- Finish the quilt as described in the *General Directions*, using the 2 1/2" x 44" purple strips for the binding.

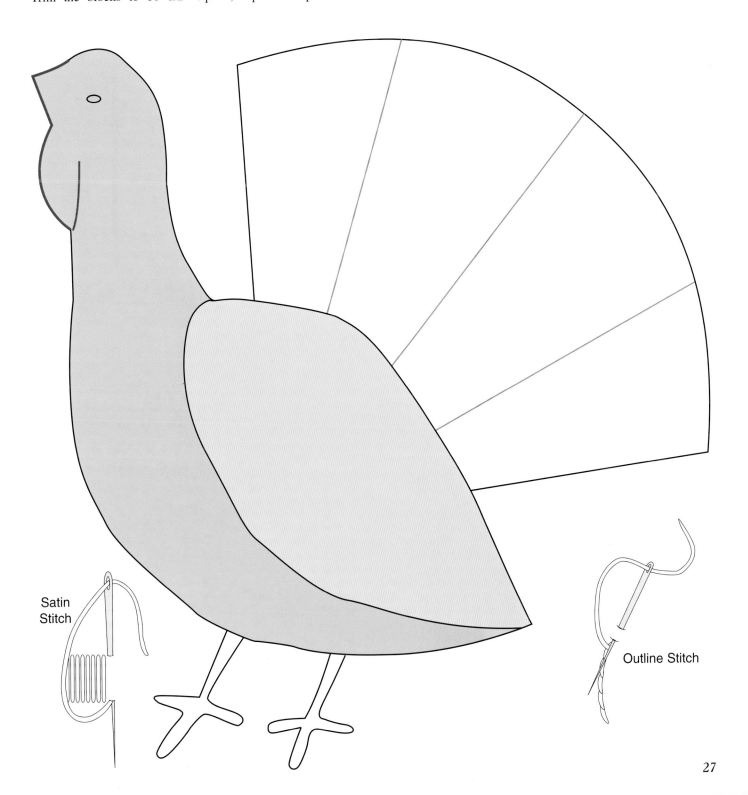

Satin Stitch

Outline Stitch

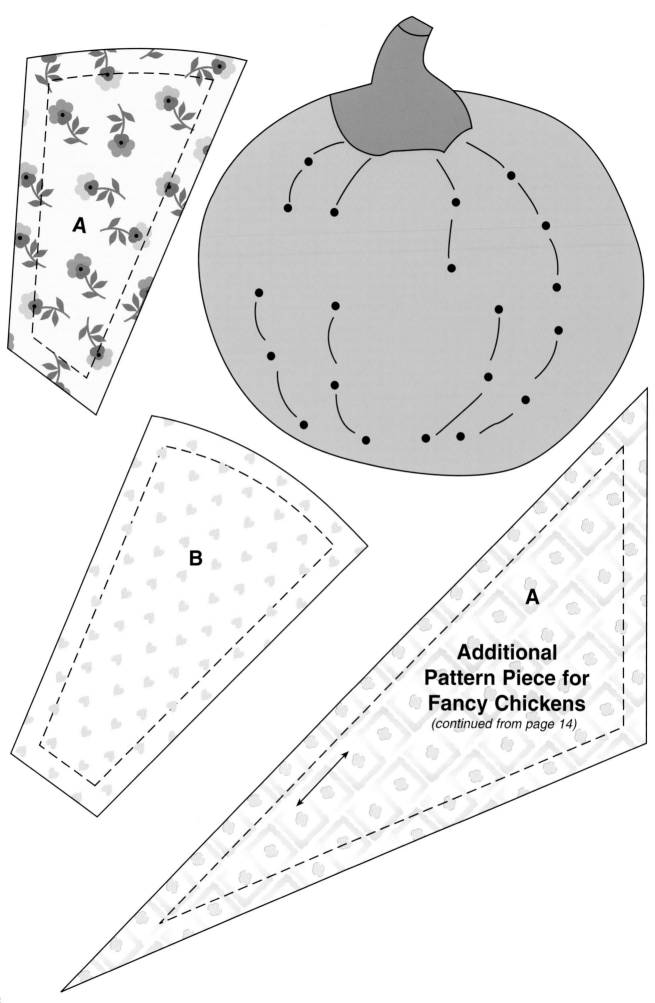

A

B

A

Additional Pattern Piece for Fancy Chickens
(continued from page 14)

Swans in the Lily Pond

Shown on page 25

This is a great hand-stitching, take-along project.

QUILT SIZE: *79 1/2" square*

BLOCK SIZE: *10 1/2" square*

MATERIALS

- Assorted prints, each at least 6" square
- 1/4 yard yellow
- 1/4 yard green
- 5 1/2 yards white
- 2 yards yellow print
- 2 yards purple print
- 7 1/4 yards backing fabric
- 84" square of batting
- Pearle cotton in yellow, blue, pink, and red

CUTTING

Appliqué patterns (page 30) are full size and do not include a turn-under allowance. Make a template of each pattern piece. Trace around the templates on the right side of the fabric and add a 1/8" to 3/16" turn-under allowance when cutting the fabric pieces out. All other dimensions include a 1/4" seam allowance. Cut the lengthwise white border strips before cutting smaller pieces from that fabric.

- Cut 25: swans, assorted prints
- Cut 25: lilies, yellow
- Cut 25: lily pads, green
- Cut 4: 3" x 70" lengthwise strips, yellow print
- Cut 4: 3" x 60" lengthwise strips, yellow print
- Cut 4: 3" x 65" lengthwise strips, purple print
- Cut 4: 6 1/2" x 82" lengthwise strips, white
- Cut 4: 2 1/2" x 82" lengthwise strips, white, for the binding
- Cut 25: 11 1/2" squares, white

DIRECTIONS

- Lightly mark the placement of a swan and water ripples on the right side of each 11 1/2" white square, placing the top of the head 2 1/4" from the edge of the square.
- Arrange a swan, lily pad, and lily on the marked square and needleturn appliqué them in the same order.
- Use yellow pearle cotton and an outline stitch to embroider around the edge of each swan and lily pad. Use red pearle cotton to embroider the swan's eye and blue pearle cotton to embroider the lily and water ripples. Make 4 french knots on the lily using pink pearle cotton.
- Make 25 blocks. Trim them to 11" square, keeping the design centered.
- Lay out the blocks in 5 rows of 5. Stitch them into rows and join the rows.
- Measure the length of the quilt. Trim 2 of the 3" x 60" yellow print strips to that measurement. Stitch them to the sides of the quilt.
- Measure the width of the quilt, including the borders. Trim the remaining 3" x 60" yellow print strips to that measure-

(continued on page 30)

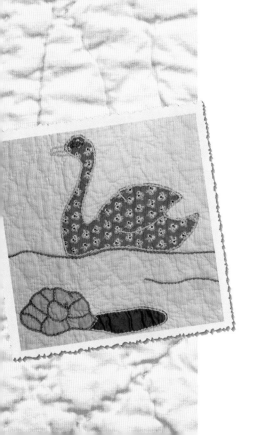

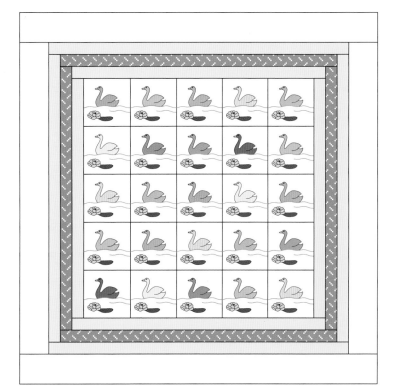

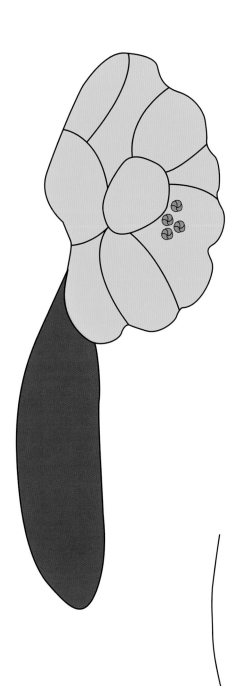

(continued from page 29)

ment. Stitch them to the top and bottom of the quilt.

• In the same manner, trim 2 of the 3" x 65" purple print strips to fit the quilt's length and stitch them to the sides of the quilt.

• Trim the remaining 3" x 65" purple print strips to fit the quilt's width and stitch them to the top and bottom of the quilt.

• Trim 2 of the 3" x 70" yellow print strips to fit the quilt's length and stitch them to the sides of the quilt.

• Trim the remaining 3" x 70" yellow print strips to fit the quilt's width and stitch them to the top and bottom of the quilt.

• Trim 2 of the 6 1/2" x 82" white strips to fit the quilt's length and stitch them to the sides of the quilt.

• Trim the remaining 6 1/2" x 82" white strips to fit the quilt's width and stitch them to the top and bottom of the quilt.

• Finish the quilt as described in the *General Directions*, using the 2 1/2" x 82" white strips for the binding.

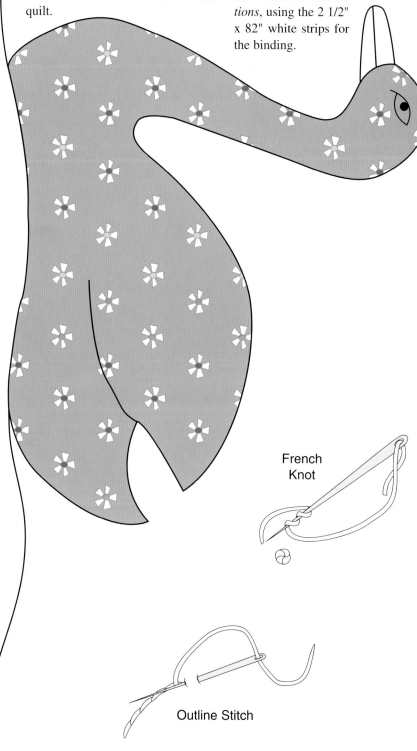

French
Knot

Outline Stitch

General Directions

Read through the pattern directions before cutting fabric. Yardage requirements are based on 44"-wide fabric with a useable width of 42". If you're sending your quilt to a professional machine quilter, consult them regarding the necessary batting and backing size. Dimensions listed in the patterns are for hand quilting.

FABRICS

I suggest using 100% cotton. Wash fabric in warm water with mild detergent and no fabric softener. Dry fabric on a warm-to-hot setting. Press with a hot dry iron to remove any wrinkles.

ROTARY CUTTING

Begin by folding the fabric in half, selvage to selvage. Make sure the selvages are even and the folded edge is smooth. Fold the fabric in half again, bringing the fold and the selvages together, again making sure everything is smooth and flat.

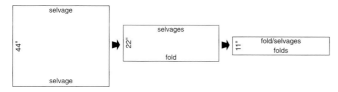

Position the folded fabric on a cutting mat so that the fabric extends to the left for right-handed people, or to the right for left-handed people.

With the ruler resting on the fabric, line up the folded edge of the fabric with a horizontal line on the ruler. Trim the uneven edge with a rotary cutter. Make a clean cut through the fabric, beginning in front of the folds and cutting through to the opposite edge with one clean stroke. Always cut away from yourself—never toward yourself!

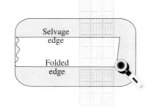

Turn the mat 180°. Move the ruler to the proper width for cutting the first strip and continue cutting until you have the required number of strips. To keep the cut edges even, always move the ruler, not the fabric.

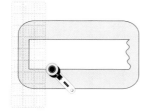

Open up one fabric strip and check the spots where there were folds. If the fabric was not evenly lined up or the ruler was incorrectly positioned, there will be a bend at each of the folds in the fabric.

When cutting many strips, check after every three or four strips to make sure they are straight.

TEMPLATES

Template patterns for piecing are full size and include a 1/4" seam allowance. The solid line is the cutting line; the dashed line is the stitching line. Place a sheet of firm, clear plastic over the patterns, and trace the cutting line and/or stitching line for each one. Templates for machine piecing include a seam allowance, templates for hand piecing generally do not. Templates for appliqué do not include seam allowances.

MARKING THE FABRIC

Test marking tools for removability before using them. Sharpen pencils often. Align the grainline on the template with the grainline of the fabric. Place a piece of fine sandpaper beneath the fabric to prevent slipping, if desired. For machine piecing, mark the right side of the fabric. For hand piecing, mark the wrong side of the fabric, and flip asymmetrical templates before tracing them. Mark and cut just enough pieces to make a sample block, and piece it to be sure your templates are accurate.

Trace appliqué templates on the right side of the fabric. Leave enough space between pieces to allow for a 1/8" to 3/16" turn-under allowance.

For fusible appliqué, trace the templates on the paper side of the fusible web. Following the manufacturer's directions, fuse the web to the wrong side of the fabrics. Cut the appliqué pieces out on the traced lines.

PIECING

For machine piecing, sew 12 stitches per inch exactly 1/4" from the edge of the fabric. To make accurate piecing easier, mark the throat plate with a piece of tape 1/4" away from the point where the needle pierces the fabric. Start and stop stitching at the cut edges except for set-in pieces.

For hand piecing, begin with a small knot and backstitch after making the first foward stitch. Continue with a small running stitch, backstitching every 3-4 stitches. Stitch directly on the marked line from point to point, not edge to edge. Finish with two or three small backstitches before cutting the thread.

APPLIQUÉ

Mark the position of the pieces on the background as instructed in the pattern. If the fabric is light, lay it over the pattern matching centers and other indicators. Trace these marks lightly. If the fabric is dark, use a light box or other light source to make tracing easier.

Appliqué pieces can be stitched in place by hand or machine.

Needleturn Appliqué

Baste or pin the pieces to the background in stitching order. Turn the edges under with your needle as you appliqué the pieces in place. Do not turn under or stitch edges that will be overlapped by other pieces.

Machine Appliqué

Baste pieces (which have been cut on the traced line) in place with a long machine basting stitch or a narrow, open zigzag stitch. Then stitch over the basting with a short, wide satin stitch. Placing

a piece of paper between the wrong side of the fabric and the feed dogs of the sewing machine will help stabilize the fabric. Carefully remove excess paper when stitching is complete. You can also turn the edges of appliqué pieces under as for needleturn appliqué, and stitch them in place with a blind-hem stitch.

Fusible Appliqué

Finish the edges of fusible appliqué pieces with a blanket stitch made either by hand or machine.

PRESSING

Press with a dry iron. Press seam allowances toward the darker of the two pieces.

FINISHING YOUR QUILT

Marking Quilting Lines

Mark the quilt top before basting it together with the batting and backing. Chalk pencils show well on dark fabrics, otherwise use a very hard (#3 or #4) pencil or other marker for this purpose. Test your marker for removability before marking your quilt.

Transfer paper designs by placing fabric over the design and tracing. A light box may be necessary for darker fabrics. Precut plastic stencils that fit the area you wish to quilt may be placed on top of the quilt and traced. Use a ruler to mark straight, even grids. Masking tape can also be used to mark straight lines. Temporary quilting stencils can be made from clear adhesive-backed paper or freezer paper and reused many times. To avoid residue, do not leave tape or adhesive-backed paper on your quilt overnight.

Outline quilting does not require marking. Simply eyeball 1/4" from the seam or stitch "in the ditch" next to the seam. To prevent uneven stitching, plan your quilting design to avoid quilting through thick seam allowances wherever possible.

Basting

Cut the batting and backing at least 4" larger than the quilt top. Tape the backing, wrong side up, on a flat surface to anchor it. Smooth the batting on top, followed by the quilt top, right side up. Baste the three layers together to form a quilt sandwich. Begin at the center and baste horizontally, then vertically. Add more lines of basting approximately every 6" until the entire top is secured.

Quilting

Quilting is done with a short, strong needle called a "between." The lower the number (size) of the needle, the larger it is. Begin with an 8 or 9 and progress to a 10 to 12. Use a thimble on the middle finger of the hand that pushes the needle. Begin quilting at the center of the quilt and work outward to keep the tension even and the quilting smooth.

Using an 18" length of quilting thread knotted at one end, insert the needle through the quilt top and batting only and bring it up exactly where you will begin. Pop the knot through the fabric to bury it. Push the needle straight down into the quilt with the thimbled finger of the upper hand and slightly depress the fabric in

front of the needle with the thumb. Redirect the needle back to the top of the quilt using the middle or index finger of the lower hand.

Repeat with each stitch using a rocking motion. Finish by knotting the thread close to the surface and popping the knot through the fabric to bury it. Remove basting when the quilting is complete.

If you wish to machine quilt, I recommend consulting one of the many fine books available on that subject.

Binding

Trim the excess batting and backing 1/4" beyond the raw edges of the quilt top. Cut binding strips with the grain for straight-edge quilts. To make 1/2" finished binding, cut 2 1/2"-wide strips. Sew strips together with diagonal seams; trim and press seam allowances open.

Fold the strip in half lengthwise, wrong side in, and press. Position the strip on the right side of the quilt top, aligning the raw edges of the binding with the edge of the quilt top. Leaving 6" of the binding strip free and beginning several inches from one corner, stitch the binding to the quilt with a 1/4" seam allowance measuring from the raw edge of the quilt top. When you reach a corner, stop stitching 1/4" from the edge of the quilt top and backstitch. Clip the threads and remove the quilt from the machine. Fold the binding up and away from the quilt, forming a 45° angle, as shown.

Keeping the angled fold secure, fold the binding back down. This fold should be even with the edge of the quilt top. Begin stitching at the fold.

Continue stitching around the quilt in this manner to within 6" of the starting point. To finish, fold both strips back along the edge of the quilt so that the folded edges meet about 3" from both lines of stitching and the binding lies flat on the quilt. Finger press to crease the folds. Measure the width of the folded binding. Cut the strips that distance beyond the folds. (In this case 1 1/4" beyond the folds.)

Open both strips and place the ends at right angles to each other, right sides together. Fold the bulk of the quilt out of your way. Join the strips with a diagonal seam as shown.

Trim the seam allowance to 1/4" and press it open. Refold the strip wrong side in. Place the binding flat against the quilt, and finish stitching it to the quilt. Trim excess batting and backing so that the binding edge will be filled with batting when you fold the binding to the back of the quilt. Blindstitch the binding to the back, covering the seamline.

Remove visible markings. Make a label that includes your name, the date the quilt was completed, and any other pertinent information, and stitch it to the back of your quilt.